GW01044432

The Country Diary Drawings

Clifford Harper would like to thank the following people for their mutual aid – Richard Boston, Roger Browning, Jayne Clementson, Gina Cross, Lisa Darnell, Luke Dodd, Simon Esterson, Annalena Macfee, Adrian Monck, Ann Morrow, Mark Porter, Marsha Rowe and Steve Sorba.

The drawings on pages 1 to 31 first appeared in the Guardian newspaper. The drawings on pages 32 to 36 appear for the first time in this edition. Published by Agraphia Press, 2003.

Designed by Clifford Harper and Jayne Clementson
Typeset by Jayne Clementson

Printed in Great Britain by Aldgate Press
Units 5/6 Gunthorpe Workshops, Gunthorpe Street, London E1 7RQ

ISBN 1 904596 00 2

Published by Agraphia Press
78a Crofton Road, Camberwell, London SE5 8NA
www.agraphia.uk.com

The Guardian

COUNTRY DIARY DRAWINGS

36 Drawings
by
CLIFFORD HARPER

Foreword by
Richard Boston

AGRAPHIA

This book is for

Jane Northcote

FOREWORD

Clifford Harper's grandfather, father, uncles and brother were all postmen. A few years ago he made his personal contribution to the mail by producing his own postage stamps. Intended for post-revolutionary post, these designs for anarchist stamps did not bear the usual portraits of heads of state, but of its enemies – anarchists and sort-of anarchists such as the Digger Gerrard Winstanley and William Godwin, Shelley, Proudhon ('property is theft'), Bakunin, Kropotkin, Oscar Wilde, Emma Goldman and Emiliano Zapata.

In his foreword to the collected stamp book Colin Ward (who also got his own stamp) told the story of a certain Francis Sedlak who made his way from Bohemia via the French Foreign Legion to arrive in 1899 at a Tolstoyan community in Gloucestershire. Here he built his own house and wrote an account of his life. He wanted to send the article to an address in London but to send it by mail would have meant not only using the government's postal system but also licking the backside of a portrait of Queen Victoria. Since this was clearly out of the question his anarchist solution to the problem was to take the manuscript on foot and

deliver it by hand.

Part of his walk would have been on the same route that more than half a century later I and thousands of others followed one Easter after the other. The four-day Aldermaston march was truly a peripatetic university, providing a whole generation with a political education. Utopian idealism mingled with hard-boiled cynicism. Many who started out chanting 'Men and women, Stand together. Do not heed the men of war. Make your minds up, now or never, ban the bomb, for evermore' were soon singing from a different hymn-sheet where the words went 'Men and women, sleep together ...' Plangent protest songs like the dire 'Where have all the flowers gone?' came later. Nor were there Walkmans or mobile phones. It was great.

With satirical intent I bought a copy of *Peace News*. Surely, I thought, with the know-all arrogance of a 20-year-old, this could not fail to provide snippets of whey-faced pacifist nonsense with which I could amuse the group of sophisticated Cambridge friends I was walking with. No such luck. The first article I read seemed pretty sensible. So did the rest of the paper. While mulling over this rather disconcerting experience I had a second go, this time investing a few pence on a rag called *Freedom*. Or was it *Freedom*'s stable-mate *Anarchy* (brilliantly edited by the same Colin Ward)? The idea of anarchists being against bombs seemed intrinsically comic. And again I was confounded. More than that, I was converted. A couple of years later I found myself on the minuscule staff of *Peace News* and I am a subscriber to *Freedom* to this day.

By no means all pacifists are anarchists, nor are all anarchists pacifists. (All anarchists aren't anything, each one being his or her own kind of anarchist, such is the nature of the beast.) Personally I have found the

two positions not just compatible, or even complementary, but actually dependent upon one another. The pacifist who refuses to put on a uniform or pick up a rifle is obeying the dictates of his conscience and challenging the authority of the state. From a different starting point the anarchist has made the acute observation that 'war is the health of the state'. This sounds like a paradox but is the simple truth. The state is never more powerful and the individual is never less so than in time of war or preparation for it. Without war the state would be redundant, just as the police would be if there were no crime. Incidentally, it is worth noting how effective the armed forces have been at making people into anarchists. Tolstoy and Kropotkin both had military backgrounds, and nearer to our own time we have Colin Ward (that man again) learning his anarchism as a wartime conscript, and George Melly shortly afterwards doing the same as a national serviceman. Joseph Heller's military novel *Catch 22* is a vivid description of the opposite of anarchy, which is chaos.

As for bomb-throwing, only the accusing finger of a madman could point at anarchists. It's the state that drops bombs. Anarchists weren't responsible for Hiroshima or Dresden or Stalingrad or Coventry. All the bombs thrown by all the anarchists in the whole of history wouldn't add up to the tonnage of a single raid as carried out routinely and daily by our elected governments in so-called peace time (I am writing this in late 2002).

I have already said that there are as many kinds of anarchism as there are anarchists, and there have indeed been bomb-throwers among them. There may possibly have even been anarchists conforming to the

cartoon stereotype with broad-brimmed hat, dark cloak, smoking spherical bomb and all. This rare bird (of the sub-species called nihilist), a rare visitor in the late nineteenth and early twentieth centuries, might have called himself an exponent of propaganda of the deed.

Anarchists have operated with alternative, sometimes rival, revolutionary strategies: propaganda of the deed and propaganda of the word. The first has ranged from assassinations and armed struggle (as in Spain) to non-violent direct action (as with, for example, the Committee of 100 or the women of Greenham Common) or constructive activities through mutual aid and cooperation in activities from agriculture to town planning and even banking.

Propaganda of the word has meanwhile used the might of the pen rather than the sword. Anarchists have always poured out torrents of words and been closely associated with printing and the press. In recent years they have also been quick to grasp the potential power of such cheap and universal media as the fax and now, and increasingly importantly, the internet. The repressiveness of a regime may be measured by the extent to which it tries to control such means of communication.

Word and deed have in practice gone forward together. The 1968 May events in France were an exhilarating example. As the barricades went up and factories and university buildings were occupied, the walls of Paris were covered with quickly-made posters carrying forceful, dramatic, witty, exciting slogans and images. Spontaneously the students who produced them reverted to the style of nineteenth-century left-wing revolutionaries, many of them anarchists. There were at that time new media to be explored, such as

lithography and photography, while the old medium of the woodcut was revitalised by the discovery of Japanese prints. Manet, Steinlen and Pissarro were among the artists of the left who produced powerful black-and-white printed images. With the work of the anarchist Felix Vallotton in particular an enormous amount of activity, observation and comment could be packed into a small space, often in ways that anticipated the great works of the silent cinema.

Clifford Harper's distinctive bold black-and-white work combines that nineteenth-century French revolutionary tradition with an English one of woodcuts and wood-engravings that includes Walter Crane, William Morris and Eric Gill and that, indeed, goes back to the great Thomas Bewick himself. Woodcuts are made using the side grain, often of apple wood. Wood-engravers use the end grain of an extremely hard wood, usually box wood or yew. Woodcuts have an attractive freedom about them, similar to that of the less durable lino-cut. Wood-engravings can use a much finer line, with effects that are more subtle. Which does Harper use?

The slightly surprising answer is that he doesn't use wood at all; nor does he make prints. He is self-taught and, anarchist that he is, has come up with something of his very own. He draws on CS10 Line Board with black ink and a Rotring Rapidograph pen with either an .01 or .03 nib. Lines and cross-hatching are scratched into the black with an Edding scalpel. The result is finer than scraper-board (a most unsympathetic medium, in my view) and is made finer still by being reduced in reproduction; Harper usually works about one-third up on what will be the finished work. So, in the end, it is a printed work after all. It's

just that in this case the printing is not done by the artist but by the newspaper or magazine it has been executed for.

The purist may have reservations about something which looks like a wood-engraving but isn't. My own view is that anything goes. If it works for the artist then it works. Anyway, nobody who has done any wood-engraving would be mistaken for long. The cross-hatching is one give-away. When he cuts the wood the engraver makes a white line. The illusion of tone is made by cross-hatching white lines on a black background. Harper's cross-hatching is often black on white; therefore it's been done with a pen.

This actually extends the vocabulary available to Harper, in that he can do two different kinds of cross-hatching. This does something to make up for what I feel he has lost in the various effects (of stippling, for example) that are available to the engraver. There is, too, a supple life in the engraver's line, the unique result of controlled manual effort, that is as special as the calligraphy of fine penmanship. But perhaps we're in danger of getting into connoisseurship here, and I don't think that that's what Harper's after. What is important is that his drawings work on the page, and in practice they work very well and in a variety of forms.

Felix Vallotton's woodcuts were just an episode in his extraordinarily productive and versatile career. Their narrative style was further developed by the Belgian artist Frans Masereel (born 1889) who in the 1920s produced entire novels without words, just black-and-white images. Harper has produced a powerful little book in this genre about a First World War deserter shot for cowardice (*The Unknown Deserter*, Working

Press). In addition there's been his book of stamps, and numerous other publications, but most of his work has appeared in fairly obscure publications with tiny circulations. It is all the more heartening that in the last few years his work has been reaching a very much wider audience, especially through the *Guardian*.

His 31 drawings for the *Guardian*'s Country Diary were immediately and deservedly popular. The Country Diary has to tread a careful path if it is not to fall into the kind of prose that Evelyn Waugh parodied with such deadly accuracy in *Scoop*. "Feather-footed through the plashy fen passes the questing vole" writes William Boot in his 'Lush Places' nature notes for *The Beast*. For the most part the *Guardian* Country Diarists avoid the boot-trap, though I confess to taking a perverse pleasure in sometimes spotting descriptive prose in which the writer has accidentally and unconsciously fallen into blank verse.

Harper's vignettes are tough enough to be a useful corrective to any tendency to romanticised lushness. Individually they continue to give pleasure however often they appear in the paper. The effect of seeing them not day by day but all together, as here in this book, is different. They seem to be telling a story the way Masereel's do. The setting is a harsh countryside. Much of the time it is night, as evidenced by stars, the moon, car-headlights and nocturnal animals such as the badger. It is usually winter, as is shown by the leafless trees or by actual snow. It is not the rural Britain of today with its foot-and-mouth and BSE and vast combine harvesters and huge cylindrical straw bales. We know this because there's a horse-drawn plough, a sight that's been rare for three-quarters of a century. But there are also huge cooling towers, and a motorway. That's odd – there's no traffic on the motorway, not a single car, and the village street is deserted.

There's a badger and a fish and a frog and quite a few birds, but no cattle, pigs or poultry and the only sheep is a lamb that looks as though it is for a church window rather than a butcher's.

And where have all the people gone? It's not just a deserted village but a whole countryside that's depopulated. There's a man and a women, and a brief moment of what might be joy as they glimpse a boat which might offer the chance of freedom, of flight like that of the bird in the sky. But when the boat sails it looks as though only one of them is in it. The solitary man seems depressed, while the solitary woman looks as though she may quite enjoy just lying on the grass with a book. It's all a bit mysterious, a bit unsettling, a bit uncomfortable.

The Country Diary drawings are intended to be seen one at a time, as they appear in the daily paper – and on newsprint, not art paper. By collecting them together they acquire (for me, at least) a narrative quality. They are also changed on seeing them on a different kind of paper, and not surrounded by columns of type but framed on a blank wall or as here in a book. The context makes a huge difference, and another context is the rest of Harper's work. I have referred to some of this already but mention should be made of other drawings on a rural theme – for example, the self-sufficiency drawings he did years ago for the book *Radical Technology* or the more recent vignettes for *Country Life* magazine. Then over the last three years or so there have been the illustrations for A.C. Grayling's 'Last Word' column and then James Fenton's weekly contributions to the Saturday *Guardian*. These are bigger in scale and (I get the impression) are making more use of tone.

Harper's work is changing and developing. Since I wrote the above he has done a further five Country Diary drawings, and he sent me a gloriously bucolic roistering Christmas/New Year card, the high spirits of which should be amply balanced by his current project of illustrating James Thomson's The City of Dreadful Night. There will be, I am sure, much else. His work is varied and rewards attention, and the Country Diary drawings are a good place to start.

1

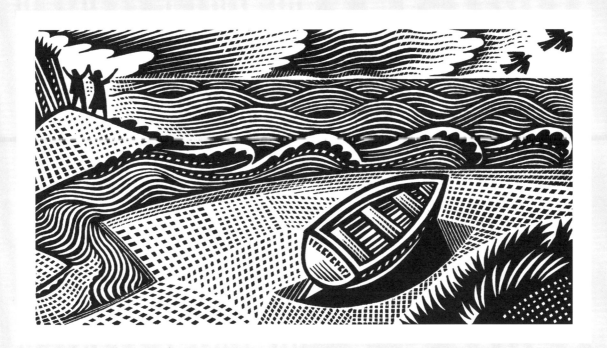

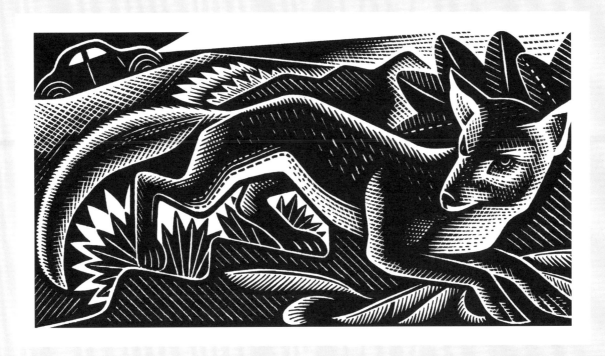

3

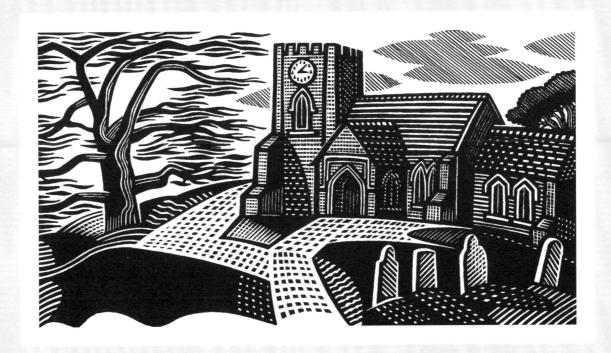

4

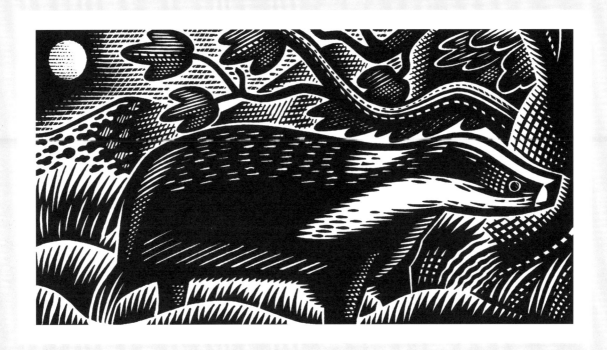

5

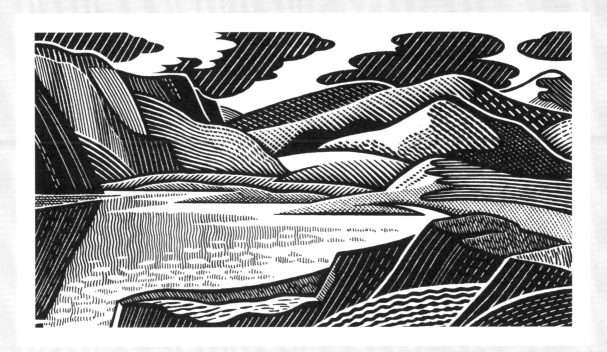

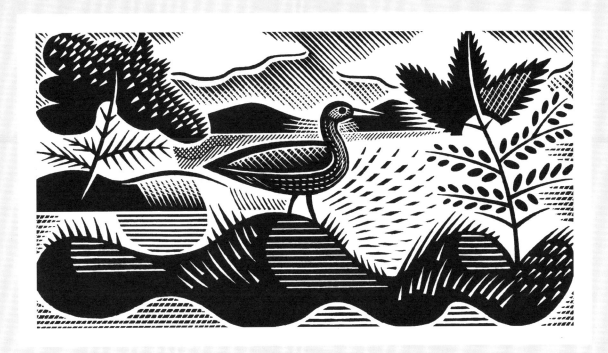

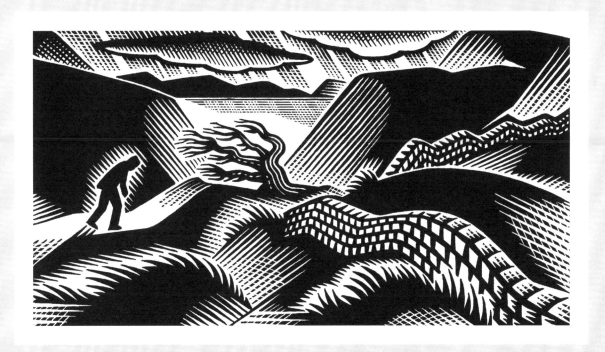

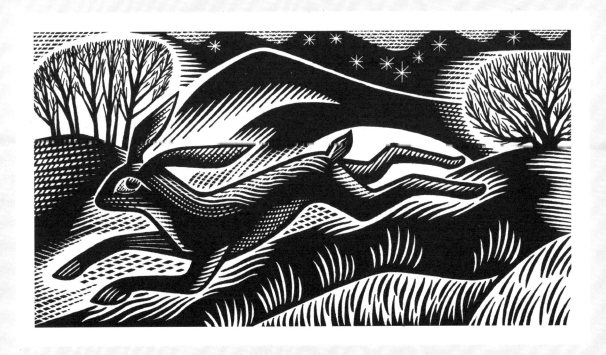

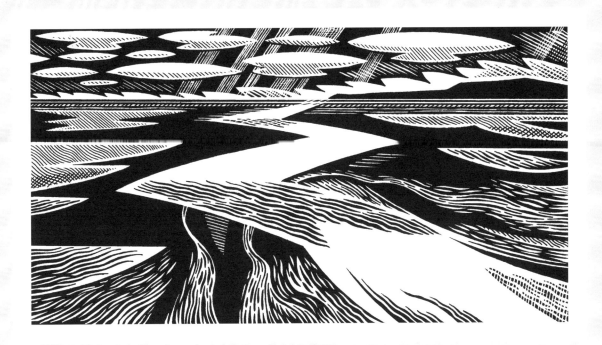

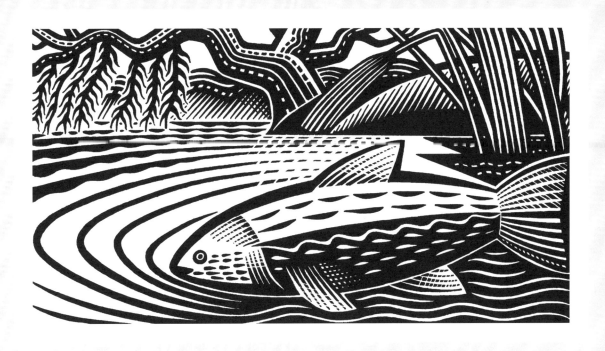

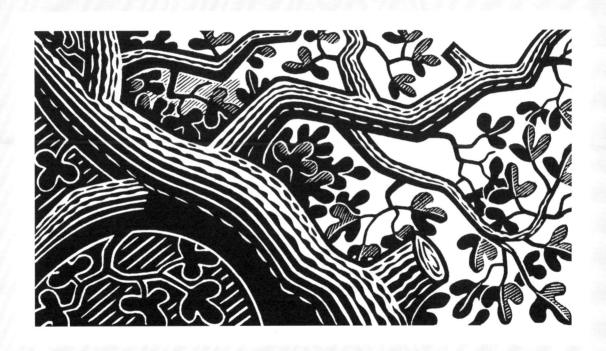

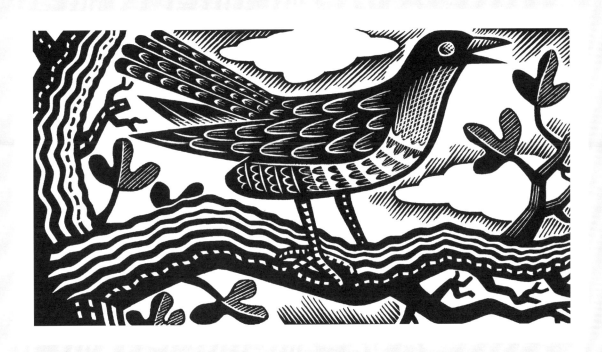

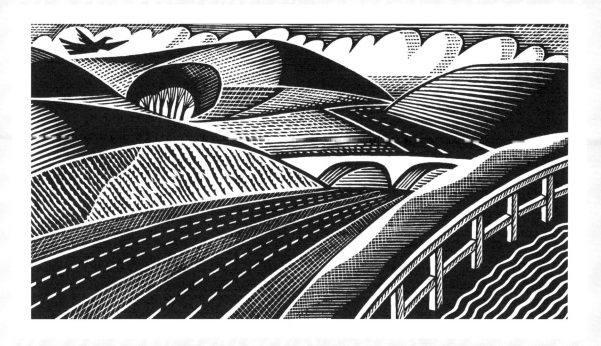

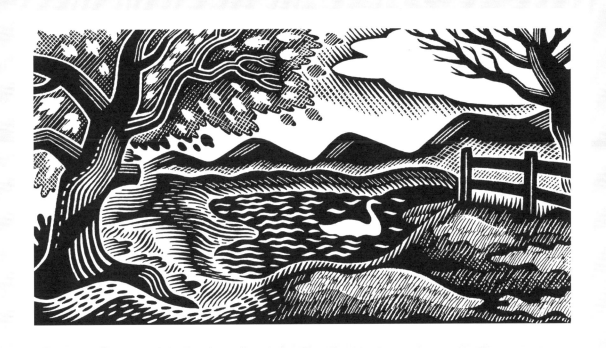

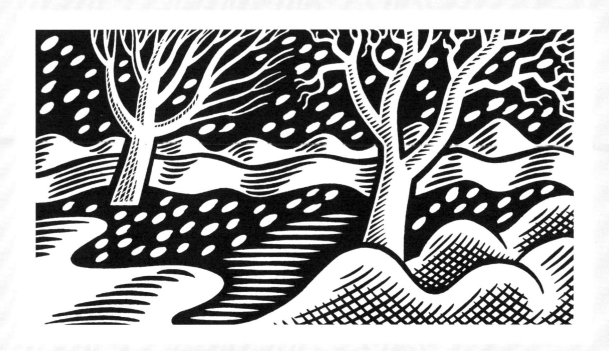

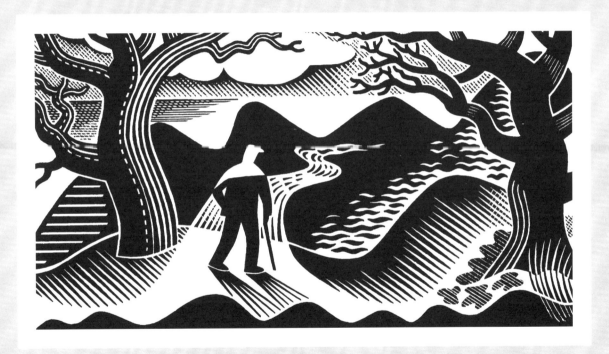

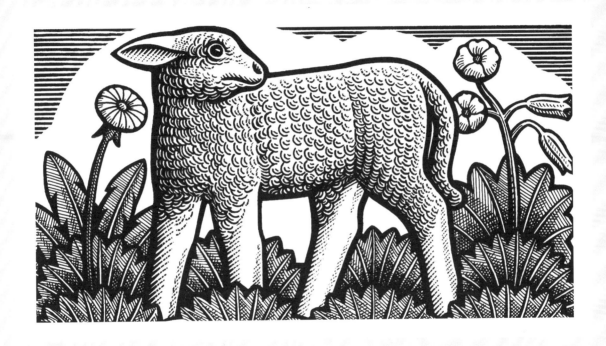

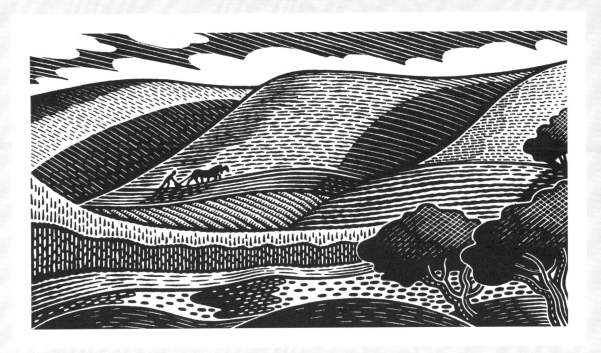

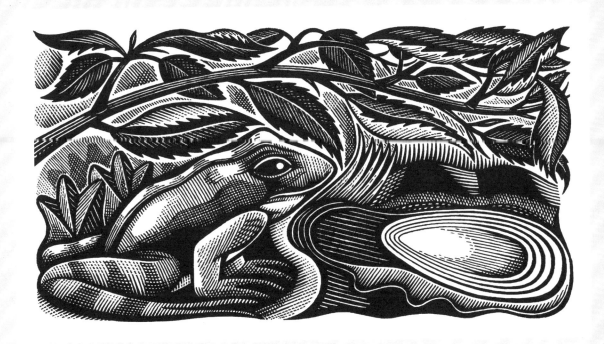

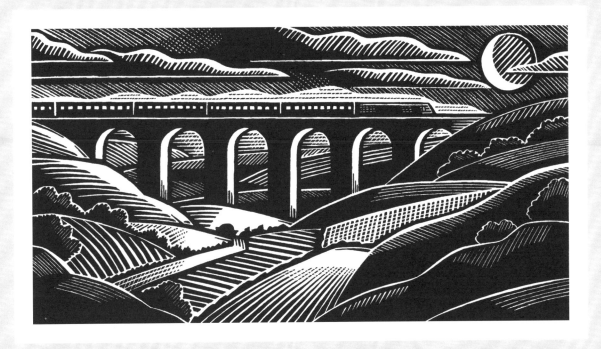

21

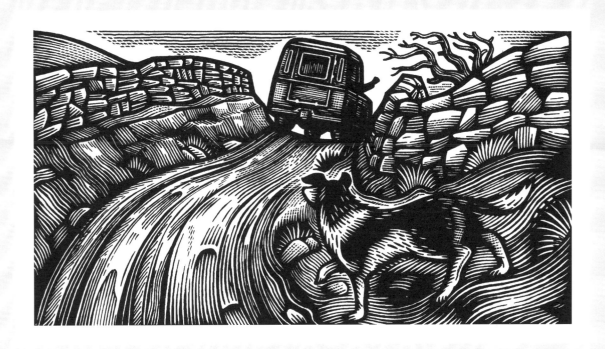

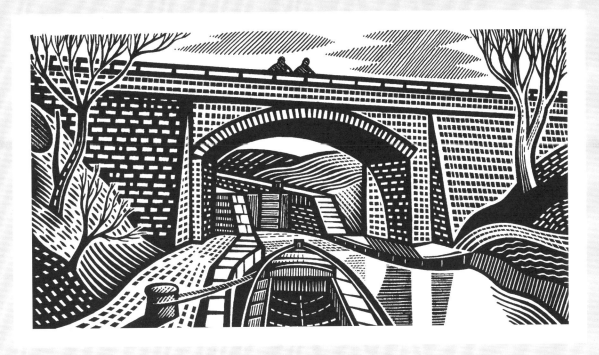

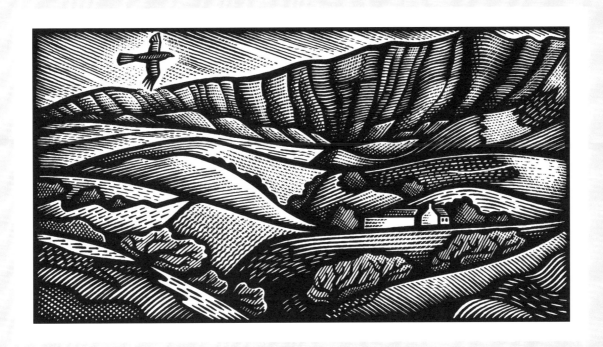

24

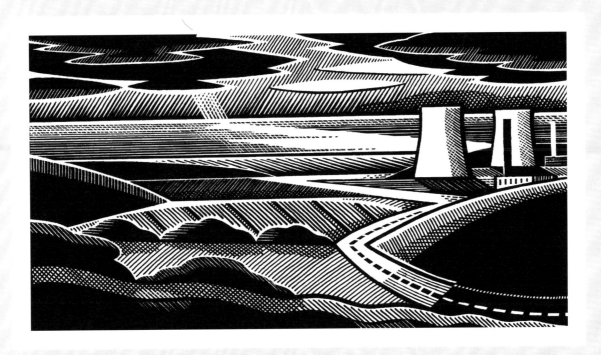

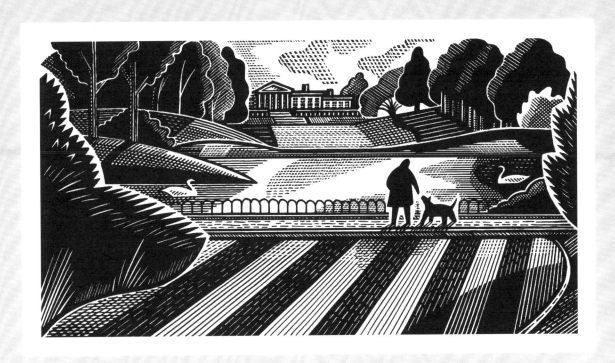

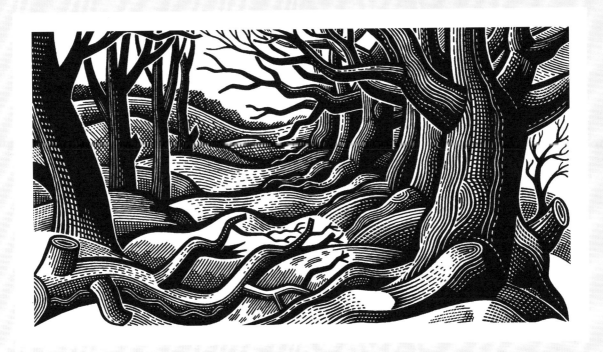

27

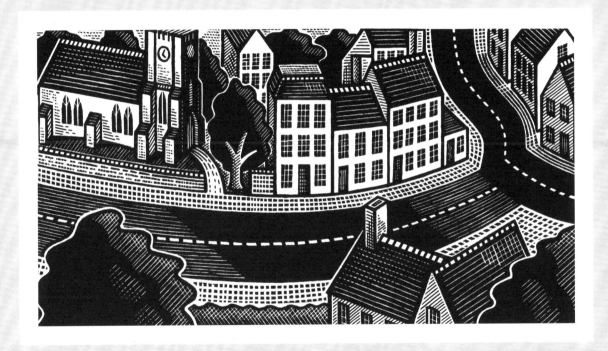

28

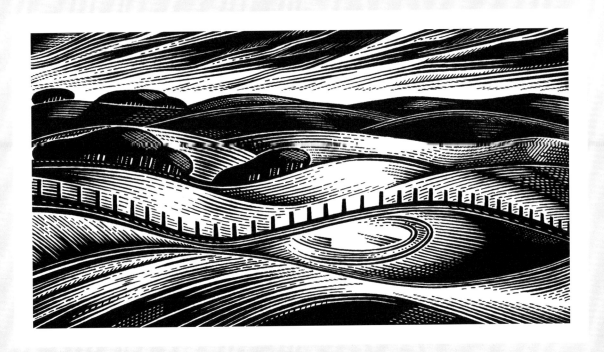

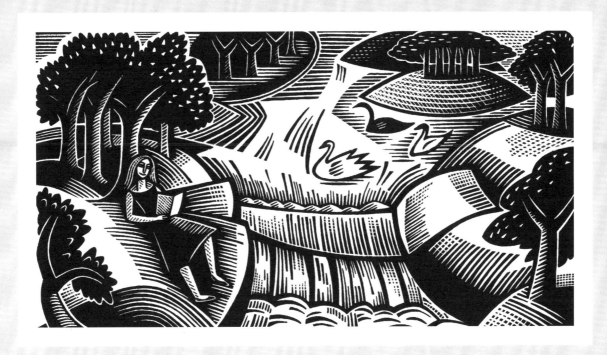

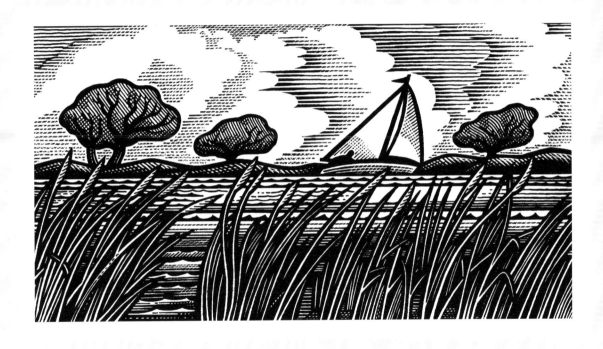

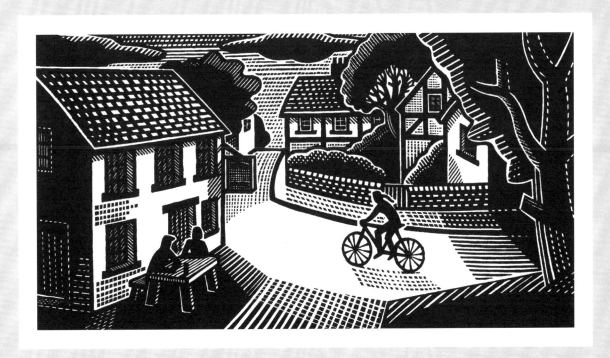

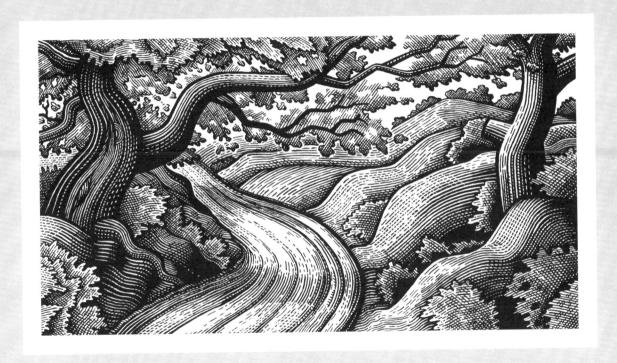

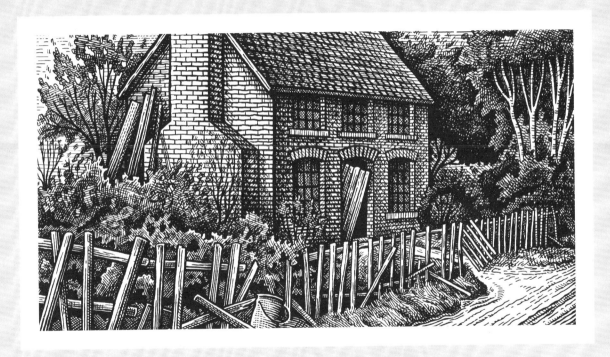

34

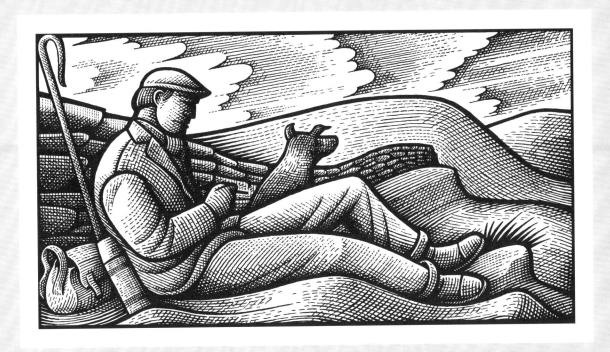

35

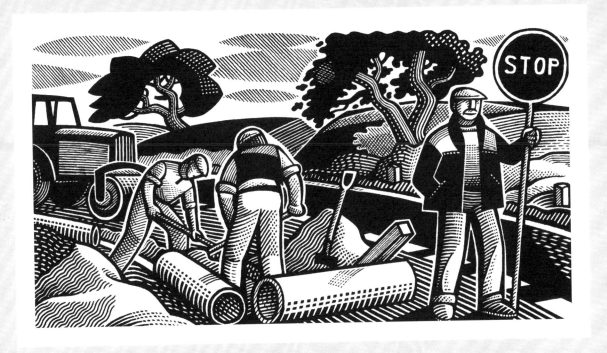

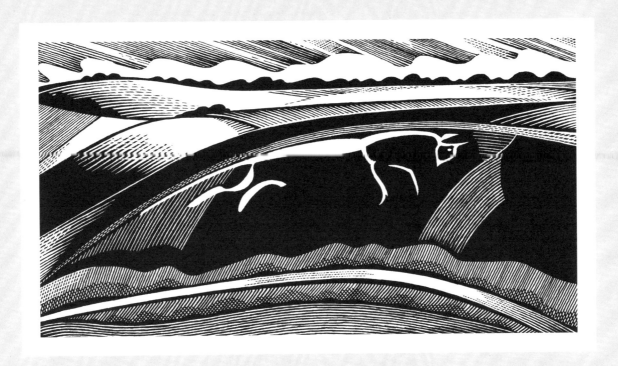

BOOKS BY CLIFFORD HARPER

THE EDUCATION OF DESIRE
the anarchist graphics of Clifford Harper
Annares Press, London, 1984

ANARCHY
a graphic guide to the history of anarchism
Camden Press, London, 1987

AN ALPHABET
twenty six drawings
Working Press, London, 1990

THE UNKNOWN DESERTER
a story in pictures
Working Press, London, 1990

ANARCHISTS
thirty six picture cards
Freedom Press, London, 1994

PROLEGOMENA
to a study of the return of the repressed in history
Rebel Press, London, 1994

VISIONS OF POESY
an anthology of twentieth century anarchist poetry
edited with Denis Gould and Jeff Cloves
Freedom Press, London, 1994

STAMPS
designs for anarchist postage stamps
Rebel Press, London, 1997

PHILOSOPHER FOOTBALLERS
sporting heroes of intellectual distinction
twenty picture cards
Philosophy Football, London, 1997

For more information on these books
and on the work of Clifford Harper
visit www.agraphia.uk.com

OTHER BOOKS FROM AGRAPHIA PRESS

THE CITY OF DREADFUL NIGHT
by James Thomson, illustrated by Clifford Harper

Thomson's epic poem first appeared in 1874 and describes the poet's journey through one night of a great city. A dark, pessimistic and deeply questioning work, this poem is a precursor of today's 'London writers' – such as Ian Sinclair and Peter Ackroyd – and deserves a new audience. Clifford Harper's drawings, done ten years ago, closely echo Thomson's own vision of urban existence. With an essay by Philip Tew.

ISBN 1 904596 01 0 8 illustrations 80 pages £10

THE BALLAD OF ROBIN HOOD AND THE DEER
Clifford Harper and John Gallas

A collaboration between a poet and an illustrator and a meditation on the nature and meaning of England's outlaw hero. Clifford Harper's drawings rescue Robin Hood from the burden of mythology and present him anew as simply a poacher and a hunted man. John Galas's ballad poem transforms the drawings into verse.

ISBN 1 904596 02 9 8 illustrations 36 pages £7

THE BALLAD OF SANTO CASERIO
John Gallas and Clifford Harper

In exchange for John Gallas's Robin Hood poem, Clifford Harper illustrated this ballad about the life and times of the Italian anarchist Santo Caserio, a baker who assassinated a French President, a little man who tried to change things and got his head chopped off. The drawings are a homage to the work of Frans Masereel and accompany perfectly the ballad verse.

ISBN 1 904596 03 7 8 illustrations 36 pages £7

To order any of these books send a cheque/PO made out to Agraphia to: Agraphia Press, 78 Crofton Road, Camberwell, London SE5 8NA or go to www.agraphia.uk.com
Prices include postage and packing. Please allow 10 to 14 days for delivery.

AGRAPHIA

agraphia / a-graf' i-a / *n.* loss of power of
writing, from brain disease or injury; fear
of, or inability to use, words. -adj. agraphic
(Gr. a-, priv., *graphein* to write).

Agraphia Press is committed to restoring the balance between illustration and text and to
maintaining the tradition of radical and didactic, black and white drawing. This tradition was at
its height between the 1890s and the 1920s and is seen at its best in the work of such artists as
Camille Pissaro, Félix Vallotton and Frans Masereel, who all shared a commitment to the ideas
of anarchism. Agraphia Press restores this unjustly neglected tradition in accessible, well
designed and low priced books and pamphlets. A picture is worth a thousand words.

For more information write to:
Agraphia Press, 78 Crofton Road, Camberwell, London SE5 8NA
or visit www.agraphia.uk.com

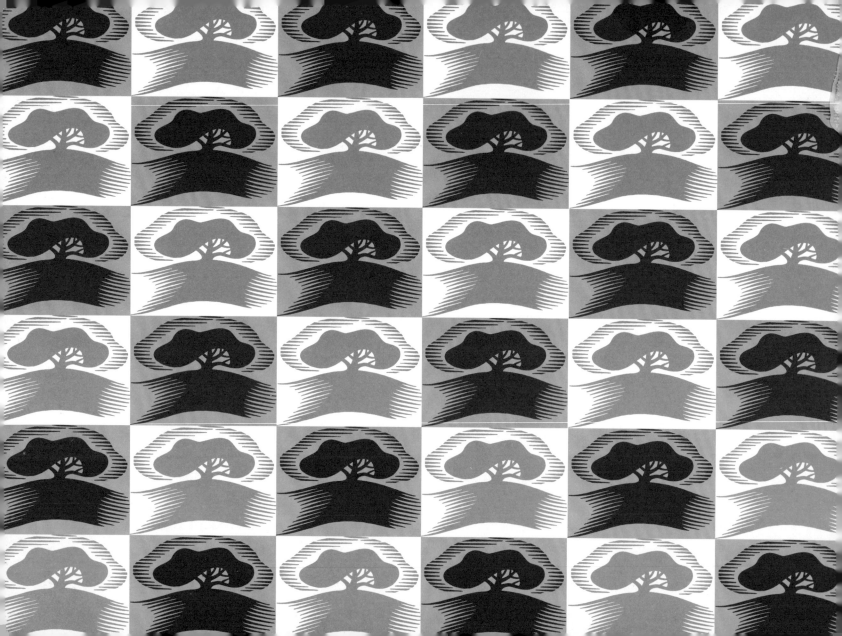